EXPRESSIONS OF A YOUNG PRINCE

by

Arthur Ford

Copyright © 2013 Arthur Ford/A Kunstler
All Rights Reserved. No part of this book
may be reproduced or utilized in any form or
by any means, electronic or mechanical,
including photocopying, without permission
in writing from the publisher.
Inquiries should be directed to:
atlkunstler@gmail.com

To all of the thinkers and dreamers

Table of Contents

Humanity and Spirituality	09
A Cry for Help	19
Surrender	31
Love and Relationship	37
Empowerment	49
Thanksgiving	61

I have to have my freedom of expression.

It's vital as oxygen.

Give me my outlet to release this intense energy from my belly.

It kicks and screams like a 9 month fetus wanting to be born.

Needing nurturing, then one day being let go into the world to find its place.

It consumes me and gives no peace until it sees the light.

HUMANITY AND SPIRITUALITY

Tall and free
you stand as upright as can be.
Confident and proud,
Not a care of what anyone else thinks.
Your function remains a tantalizing
mystery to all whom encounter you.
Your beautiful headpiece adds elegance
to your gracious presence.
Not a care in the world,
yet so beautiful.
Never searching or asking for anything,
Yet, each morning as the sun rises,
you rub your feet across the smooth wet rocks.
Feet are growing and making a strong
foundation that will keep you
as a beam of hope, but mystery
for generations to come.
Oh endow me with just a small
portion of your self-discipline.
For if I were able to sit still for even a fraction,
only then will I hear from heaven.

Step-Father

You think I didn't know, but I do.
That couldn't replace the words "I Love You."
I understood then as I do now,
no one really showed you how.
Yet, you do the best you can.
Didn't have to raise the seed of another man.
Today I just want u to know that I knew.

I'm so glad to be alive.

Alive in my spirit,

awake to the moment.

Knowing what I know,

I have been asleep for 25 years.

Walking around with my eyes open,

but asleep.

Now that I am awakened,

I have become one with the universe.

I have come close to the being

that lies in the deep.

I hear it when it speaks.

It tells me the importance of every element.

How every element relates to the other,

How we are all connected.

On the deepest level,

I affect you,

You affect me,

We affect the universe.

If we only knew who we were. Not the false sifted through history they feed us. We are the promised heirs. Lost, confused, and running around blindly. Doing the very things that got us to this place. No clue on where we're going because we do not know where we've been.

We mastered science, medicine, astronomy, geometry thousands of years ago. We were kings and queens of dynasties with their own currency and government. So advanced that we forgot about YAHWEH the God of our fathers. We were then cursed and scattered among the nations. Sold into slavery, broken down and forced to serve other Gods.

"If my people, who are called by my name, will humble themselves and pray and seek my face and turn from their wicked ways, then I will hear from heaven and, I will forgive their sins and I will heal their land."
 II Chronicles 7:14

Let's wake up. Let's get back to the place where we belong. The truth is within us all. Awaken you are God's chosen people.

Screaming to the top of their voices

through their eyes.

If you look deeply

that's were their story abides.

Just want to be hugged and kissed,

tired of the emotional strains

of mamas angry fits.

Raised by children cuz mama's running the streets.

Aint got time for her children cuz she's fucking every guy she meets.

Never taking the time to get to know the precious gifts she possesses.

Always busy talking on the phone or sending text messages.

Looking good and hitting the club is her priority.

She should be focused on raising decent members of society.

She is just continuing the cycle started by her mother, she did the same thing to her and her sisters and brothers.

See, her grandmother had her mother at 16, and her mom had her at 15, and she had her first at 14.

Really can't expect you to be responsible because you are only a teen.

How do we end this trend?

How do we start to heal our young sistas from within?

I feel so free.

I'm on one accord with Thee.

Great I AM you see.

He lives inside of me; and I in Him.

Not fooled by man-made images of him.

Not blinded by the half-truths spoken of him.

In Spirit and in Truth

I worship you.

All things I can do through you,

with patience and not being anxious

I can reach all my goals or you might just

exceed my expectations.

Living in the now allowing my soul to flow freely.

You see, I found that when I worry that only brings

more things that provoke that feeling to me.

You see, I take the time to feel the breezes brush my face.

I sit still, releasing my thoughts, meditating on his grace until I reach that place.

When I vibe with the viber and I feel its vibes through me,

it's the feeling of peace, love, and pure serenity.

Attracting nothing but positivity.

So quit asking and trying to figure out what your path is,

Search inside, The Most High abides in the stillness.

We have been so conditioned that we have lost sense of self.
Always looking to someone else to tell us how we should Live, eat and even vacation.
We look external for internal problems.
I like to call it instant gratification.
The problem with instant gratification,
Is that it is instantly there and then instantly gone.
Afterwards, you are left looking for the next thing
That will give you that same sensation or better.
We have to realize that everything that we need
Is within.
You are a part of the highest power.
We pay so much attention to the exterior
And neglect the interior.
The interior is the source of what was, what is, and what will be.
When the outward has gone on,
That which is within lasts forever.
If you need love, peace, guidance, acceptance
Or faith, search within.
What you find on the inside will eventually come out.
You don't need therapy, organized religion, or the government.

There is coming a time when people will gain the faith
Confidence and pride to live freely.
Free without the boundaries or limits.
There will be peace because no one will feel
Superior or inferior to anyone.
Everyone will be on one accord;
Connected by the connector;
Living life as it was meant to be;
Abundantly, fruitfully, fearless and free.
What a great day that will be when the
Human race awakens to its full potential.
They discover the power that has always been.

A CRY FOR HELP

Throughout life you have been with me.
You have always protected me and provided me with everything I need. I thank you so much.
I'm very confused about a lot of things.
I know that in due time all will be revealed.
I will keep my head in faith and I will move forward in the will of the Most High.
Knowing that you will continue to protect me and give me everything I need.
I love you and thank you for everything.
I ask for your protection and guidance.
Work out all the situations that need to be worked out.
Lord guide me in the right direction.
I surrender to your will that it shall be done in my life. Forgive me for transgressions and anything that I've done not pleasing to you.
Search my heart and purify it with your love, wisdom, and knowledge.
I love you eternally.

What happened to me?

Don't feel like the person I used to be.

Not doing the things I use to do,

had so much to go through.

Mind spinning out of control,

my temper flares and nothing can withhold.

I search for that place in the deep.

That place that never weeps,

No one can touch this place you see.

It is accessible to all of humanity.

Peace, love, and serenity

are a few adjectives pointing the way of the nameless

which cannot be spoken.

Words can point the way to it.

Yet, this is only half the way,

the other way is doing.

Feeling like something is missing.
Going in circles trying to find something to fix it.
No matter how hard I try,
in this material world nothing is fulfilling.
Lost my joy and it has been replaced with a spirit of confusion.
What do I do?
Where do I go?
I refuse to go back to the illusion.
Calling from the deep to the deep,
who is and always was,
renew me, restore me,
I need something that can only come from above.
Fill that place.
Occupy that place,
until there is no longer any longing for that which is nameless.
Full of love and always blameless.
Pure, true, all knowing, and sovereign of all.

Lost, going in circles. Confusion all fall on me like a ton of bricks.

It's as if I have a deep sense of purpose, without a roadmap.

No physical guide;

Yet I am aware that I have a light that shines brighter than any star in the sky.

Somewhere through the journey of life,

I've collected souvenirs from each stop.

The baggage now blocks the sunlight from shining through the windows.

Deep down there is hope.

Although it is cloudy at times,

the sun shines 24/7 365 days a year

at some point on the earth.

If I'm blessed enough, it's coming back to my town someday.

To be me,

a young black man with so many aspirations,

with no personal role model.

You see where I'm from,

the cracks of the sidewalk,

this type of life comes

with many directions but lacking instructions.

I emulate what I see.

Though most of what I see,

lacks substance and ultimately tragedies.

No one to my left or right saying here is a positive way out.

Yet many leading me swiftly to destruction.

Oh too many behind me pulling me back.

Holding me back not wanting me to see my full potential.

Constantly enticing me to fall off track.

I dream of one day playing for a championship team.

Maybe I'll be on TV or the silver screen.

Then I awake and look out of my window.

Those dreams become a fantasy.

All I see is gangstas, dope boys, blind leading the blind, and fiends.

Sometimes I feel like I want to explode on the inside. There is a disconnect. A longing for something and I'm not sure of the means. I wish I could figure it out. They say being sad or down is a choice. Am I choosing to be this way? I need direction. I want to live a fulfilled life. I understand that there may be times that are challenging, but I want the underlying energy source to be joy. I'm tired of walking blindly trying to see where I end up. I'm not asking for anyone else's life, possessions, or anything else. I just want what is for me.

Journal Entry:

In writing, I found a best friend who will never tell my secrets. That is, unless I wanted them to be told. Whenever I feel confused, angry, or can't explain how I feel, writing gives me relief. Try writing out something that is difficult for you to express verbally.

I remember a time when I felt that the world and everything in it was at my finger tips. I felt outgoing, free, like I could be and achieve anything I conceived. What happened to that spirit? I think I probably put faith in the wrong things. When they crashed, a lot of me crashed too. I'm determined to reach back in and find that person within, a courageous leader that knows what he wants.

Journal Entry:

Have you ever had a dream or goal right at your finger tips, only to slip right through? The apostle Paul reminds us in the New Testament that there will be times when you have to encourage yourself. Imagine that you are someone on the outside looking in on your current situation. Write a few words to encourage yourself.

So many things to do yet there is nothing to do.
So many ideas, but they move too swiftly to grab.
I need to pick one direction and just go.
Stop thinking and pondering about it. Just go.
What is it that I want for the long term?
What can I do now? What do I want to do now?
I need to give it some serious thought.
Be honest with myself.

Journal Entry:

Is there something you really want to do, but have been putting it off? The first step to reaching any goal is to put it on paper. "Write the vision and make it plain." Habakkuk 2:2

Feeling a lot of energy. Feeling confused as usual. I need clarity. Sometimes I don't know what I'm feeling or thinking.

<p style="text-align:center">
Lord I want to live the best of life.

I want to be filled and fulfilled.

Whatever my purpose is, I want to start living it.

Shield and protect me.

Give me peace that passes all understanding.

Oh Lord I love you show me the desires of my heart.

Put the right people and circumstances together to get me where I need to be.

I'm tired of living at the bottom.

I want to live the abundant life.

Enlarge my territory.

Bless me indeed.
</p>

Journal Entry:

We make our boldest decisions when we are at our breaking point. Something about having our backs against the wall, drives us to take direct and immediate action. Take authority in your life and declare today that you will decide and take action to better yourself today. What is your affirmation or prayer?

I learn the truth and I stray. I know my worth and stray. I know who and whose I am yet I stray. I know the consequences and I continue stray. I stray in my mind and it manifests in my body. Almighty purify my heart and my thoughts. Have mercy on me and keep your hand upon me.

Journal Entry:

I'm sure you are familiar with the maxim, "confession is good for the soul." Take a hard honest look at yourself. Are there any areas of your life that you know you need to change? PSYCH 101, The first step to solving any problem, is admitting that there is a problem. Make your confessions plain. Release the weights that your soul may be free.

SURRENDER

Never knowing my true intentions,

I went along my own path.

I tried to do, what I thought, was fulfilling.

Not inquiring with you until I felt your wrath.

I did a little of this and a lot of that;

it's a wonder I'm still alive as a matter a fact.

Although I left you, you never left me.

I'm grateful that you love unconditionally and your word is true.

During the times when I loaded you with my gripes and requests,

you never rejected me, instead reminded me that I was already blessed.

In my wilderness with no one to talk to or anyone that understood my case,

in due time you lifted me from a dark pit and placed me in a high place.

A high place spiritually and mentally,

you showed me who you really are.

Reignited the light inside of me and now I shine brighter than any star.

I'm so grateful now that I know who and whose I am.

You live in me, I live in you.

I'm a reflection of my creator even down to the last gram.

Lord make the plan plain for me. I know whatever it is, I'm okay because you are with me. I tried it on my own but it always leads to nowhere. Order my steps, be the lamp unto my feet. Show me the way that I'm supposed to go. I surrender all to you. Every situation, emotion, etc. I lay it all at your feet. What will you have me to do?

Thank you Lord for everything. I thank you for keeping me through it all. You have a divine plan. I'm learning to just allow that plan to happen.

When I was younger, I remember the old people use to say, "Jus keep livin' baby." Never really knew what that meant. It means exactly what it implies. Just keep living and life will teach you all of its lessons. It's up to us to accept and apply.

At times, it can be hard to recognize the lesson during the peak of the objective. Funny how life seems to always have a different plan than the plan we map out for ourselves. Then again, is it us that has another plan, other than the plan that was already set for us since the beginning of time? Everything has a purpose and is aligned with the greater good. Life teaches you who's the boss in the end.

What is living? Living is allowing the light of the Most High to shine through you in a world inundated with darkness. Living is having an abundance of love for those around you. Living is seeing everyone around you living to the best of their abilities.

Journal Entry:

What is your definition of living?

"Life is for the Living."

~Langston Hughes

In life when you can't figure out why things are happening, that is when the Most High is at work. Those are the times when I sit back and enjoy the ride. The Most High is in control and never makes a mistake. There is a divine plan at work.

I submit and surrender to the will of the Most High to take over and lead where I should go. I've tried it my way. I've tried to figure it out. I can make no sense; neither can I think of a way out. This is the perfect formula for the Most High.

I know that one day I will look back on this day as I have others, with understanding and the wisdom that I will gain in the end. Praises to the Most High for life and his infinite knowledge and wisdom.

LOVE AND RELATIONSHIPS

Where did it go wrong?

When did things change for the bad?

We've drifted so far from

"Up so High" our first song.

Both wanting the same thing.

Lacking the basic tool

of communication to ask

for what we need.

Never reaching a place of comfort

to say this is it.

Never secure enough to turn the heat up,

pilot always barely lit.

So absorbed in each other

no one or anything else counts.

Guess we spent too much

time together,

that may be the reason we've burned out.

Time and time again we leave,

find our way back to each other.

Only to go up and down,

loving, then fighting each other.

All I want is the real unadulterated you.

In return I'll take you on

a fantasy ride,

to the deepest part of me

that seamlessly connects to you.

Something most people hope for,

wish for, search for,

but never comes true.

To be connected with someone

who breaths the same breaths

and has the same heart rhythm

as you do.

Bright as the sun giving light to my soul.

Your pretty green eyes, I think you're a Leo.

Inspire me to be the best that I can be,

help me turn my dreams into reality.

The kinda persona that demands respect.

Just looking at you I know that I have acquired the best.

This appears to be too good to be true.

I'll just live in the moment,

no one has ever made me feel like you do.

Your words are poetic sonnets seducing me

to the inner core.

Your presence is so strong mightier than

a lion's roar

Like fine china,

I have to handle you with care.

Like a fine piece of art,

sometimes at you all I can do is stare.

Got me reevaluating myself, my heart,

and my thoughts.

Regenerating and rejuvenating me giving me

something that can't be bought.

Finally I have something real that isn't clouded
by material, lust, or ecstasy.
You see never falling for the okie doke
shawty is new breed.

Didn't have to reveal much or
give up the cookies to get my attention.
Made me feel comfortable to be me and
put aside my malicious intentions.

All good things come to an end they say.
I guess it's true,
after 3 days I opened my hands
and my butterfly flew away.

Um that place.

I can tell when you are there

by the expression on your face.

Eyes rolling to the back of your head,

the screeching sound as the mattress

is about fall off of the bed.

We're somewhere over the rainbow

way up so high.

This shit got me feeling like

I'm way past the clouds in the sky.

Harder, harder, deeper, deeper,

your nails digging in my back.

You whisper in my ear,

"Damn, you're a keeper."

This gives me the stamina of the hulk,

I turn you over kiss your neck

while killing you softly in the buck.

But no you decide you want to be in control.

Jumped on top of me and did your thing,

now it's my eyes that begin to roll.

My toes start to curl,

as I watch you make that ass twirl.

Stop! Stop! I'm not ready!

You like the effect you have on me

so you go faster.

Then BOOM like confetti,

I let loose all over of you.

You stop, give me a kiss,

lay on my chest,

Then softly say "I love you Boo.

You're the best."

Took the chance and gave you all of me.
Was genuine, let my guards down showed you vulnerability.
Looked at you like I saw a new day.
Every time you looked at me you blushed,
It made me feel good cuz no one has ever looked at me that way.
Swallowed my pride and let you slide.
Let you have your way can't say I didn't compromise.
Tighter than skinny jeans you and I.
When you would go through things, on my shoulder you would cry.
When moms wasn't around,
friends put you down,
before your tears could hit the ground,
I would stretch out my arms to you.
Not looking for an award,
I was your man,
that's what I was supposed to do.
Just wish you had extended the same courtesy,
always got some drama going on,
thinking you had me deceived.
When we met I told you
I wasn't looking for anything serious,
you kept pressing the issue.
Said that there was a special chemistry between us.

Year passed and I still didn't pay you that much attention.

You can be very persistent,

I started to admire your ambition.

Told you who I was and all of things that happened in my past.

Was always up front with you,

and answered all the questions you asked.

Constantly telling me how different you are

and you're not like other folk.

I kinda blame myself because

I don't usually fall for the okie doke.

Is it me or is it you?

Seems like everything changed when I committed to you.

I think you are just the type that enjoys the chase,

When I didn't pay your ass no attention,

I couldn't get you out of my face.

Talking bout how you never met no one like me

and if you and I got together we could be

a power couple like the people on TV.

As soon as I signed the dotted line,

You changed oh so swiftly.

Good thing I have a good sense of who I am.

Always trying to convince me that I'm the foul one,

damn.

Say,"You need to accept responsibility for your

actions."

Hell I do the same things I did back then,

but I guess back then they were attractions.

Maybe I should have kept ignoring your ass.

At least that way

our friendship would last.

I would say shame on you,

but shame on me

for entertaining the thought

You and I could ever be ONE.

EMPOWERMENT

I wait each second of the day faithfully,

like a lion hunting prey.

Sitting, choosing, waiting for that perfect opportunity.

The opportunity that I dreamed about,

but can't put into words.

When it arrives I will know.

That feeling on the inside that yearns for it will let me know it's there.

My freedom, stability, sense of self,

some might call it destiny or my path.

Whatever it is, I want it.

I thrive and thirst for it each waking moment.

I go to sleep.

It meets me in my dreams,

assuring me that it's coming.

Some days I sit and imagine how it will feel.

Yet, I don't think I could muster up the feelings in my deepest treasure chest of imaginations.

I wake up in the morning.

I get out of bed.

I reflect on your grace,

I anticipate the day.

Nothing but goodness and prosperity,

will come my way if I keep my mind on Thee.

Gaze out of the window.

Look out onto the streets.

I could get disappointed by my surroundings.

Instead I stay focused, keep my eye on the prize.

I know that this too shall pass and above this I shall rise.

Every single day
can't forget to pray
I know you'll supply all my needs
You did it yesterday
You'll do it again today

I get down on my knees
I began to pray
I know that the Lord will make a way
Each and everyday
He makes a way

If we only knew our potential. I believe that our potential is endless. We live in a world of infinite possibilities. Taping into them is the difficult part. If we shake the conditioned mind and see the world through new eyes moment by moment, we will view ourselves and the world around us in a different light.

At times as this, I ask the Most High to increase my faith. It is when the external looks like a total failure that I need to rely on my faith. In the past, whenever it appears to be unbearable, a breakthrough comes forward…

I look forward to all of what life has to offer. I anticipate the growth and development. I'm determined to learn from and overcome anything that comes against me.

When I look back at what I would consider low points, those are actually the times when I've learned the most. My prayer is that the Most High is pleased at my passing of the tests.

Wow, as I'm writing this, I'm starting to contemplate on that. Am I pleasing to the Most High? Does he sit back and marvel at me as a father does when he sees his son.

I know that his love for me never changes. I just need to make sure that my thoughts, actions, and heart all work simultaneously to please him. Thanks and praises to the Most High.

Life can be mysterious.

People say I'm mysterious.

I think I'm just open to the mysteries.

Always looking for answers.

Eventually all answers are revealed.

All works for the good in the end.

Just like the lines on a heart monitor life has its highs and lows.

You have to be open to the mysteries of life.

At its peak, it's all worth it, and the lows are all worth knowing.

Life is full of decisions. The key is making the right decision. Follow you heart. It will never lead you down the wrong path. I've found that sometimes your mind can lead you the wrong way. After all, it is conditioned by our thoughts, experiences, and what we are taught. Can't count the amount of times I've almost allowed my mind to talk me out of opportunities. If it feels right. 9 times out of 10 it is right. Go with your heart.

Journal Entry:
Get off of the mental train. What is your heart's desire?

I let go! I let go of everything. All is well. Everything is and has always been about the bigger picture. Worrying sometimes consumes the place of acceptance. I release worry and I let you go. I'm exactly where I'm supposed to be. I haven't reached my destination, but I feel that I'm on my way. I've been on this journey for a long time. Many storms, bumps, flat tires and at times the motor completely shut down. Somehow, it always seems to come together and everything is back up and running. My biggest struggle is to sit back and enjoy the ride. I miss out on the scenery because I'm so anxious to get there. Oh, when I get there I will know. I will feel it and see it. I see it in my head. I see it in my dreams at night. At times it seems like it's been forever. Instead I have to look back at the distance I've come. I'm just that much closer.

I feel the pulsating energy of life running through me,
and I through it.
One with the nameless all-knowing entity.
An adjective close to describing it would be a holy
sanctified pure bliss.
Streams of the I Am ever flowing giving insight of what
is.
All I need is here; power, wisdom, and ability.
In a place where I can do all things,
if I am discipline enough to be still.
Still, but in motion guided by the source that is and
always will be.

THANKSGIVING

Thank you Lord for everything you've done for me.

I really just have to say thank you.

The things that you have done and been for me, there are no words to express.

You are the spark of hope, the constant joy, and the permanence.

Though, these words only serve as a guidepost to the feelings that you give me.

Infinite and matchless.

When I dare to think of all that you are, a shiver paralyzes me and I curl into a ball.

Thank you for always being here.

You are the best thing about life.

You are life.

Life is you.

Life is me.

Thanks for the opportunity to know you.

To experience you.

To feel you.

All praises to the Most High for all his many blessings.

I AM more than a conqueror.

I have everything I need.

All of my needs are fulfilled.

It's a blessing to be a part of a royal priesthood.

All my dreams are validated and have worked for my good.

My family is together.

There is peace and harmony.

I am loaded daily with benefits.

I live in abundance.

I have an overflowing amount of joy.

Greatest force I have ever felt is the constant presence of the Creator.

To trust you is to know you.

You never seem to let me down.

When circumstances heat up and seem the worst, you always make a way before it reaches a boiling point.

I want to sincerely thank you for all that you do.

Words can't express what I want to say and how I feel about you.

You are everything to me.

You work so fast that it scares me at times.

Whenever you reveal just a glimpse of your glory I feel honored yet fearful.

Such a mighty presence you are.

Thanks for filling the gaps and the voids.

I give you me and all that I am to align with your way.

I yield to myself and bring forth you.

Lead wherever you see fit.

When I try to think of ways to explain you, my mind goes blank for words. Then I realize that there are no words to describe you. I can however describe the feeling, but only a portion. It's the peace that surpasses all. The peace and security I feel while resting in your care. Your care equals no cares on my part. It's the feeling of being part of an all-knowing, everlasting entity. It's the feeling of ease knowing that you are in control of all things. I see you in the flowers and the trees. I hear you at night when the crickets began to sing their songs. I feel you in the late afternoon winds as they brush across my face. I smell you when I walk through the park and bask in the ambiance of wildlife. Oh taste and see that you are good. The best way to describe you is with a smile.

I am grateful for life and all it presents. Thankful for everything. Knowing that I am exactly where I'm supposed to be. I thank God for the moments of stillness. I get to reflect and figure things out. Life is good and has a divine plan. I've learned to just go with it. Life's plans always seem to work out better than mine. I sit and observe the things that come to me. Realizing that I attract them. I've realized that my happiness comes from within. If I give off and out what I want, that plus more will return to me. I strive to give love, compassion, and hope to all I encounter.

All praises to the Most High for his infinite all-knowing wisdom and power. Thanks so much for everything. Thanks for the wisdom and knowledge. Thanks for the enlightenment. Thanks for always giving me the desires of my heart. Thanks for always being there and never leaving me. Thanks for teaching me that I have a choice in everything. It's up to me to make the choice that is aligned in your will. I choose today to be the best person I can be. My up-most request is to be pleasing in your sight. My soul rejoices at your might. I'm opening up so that you may flow through me. I want to make sure that my purpose is fulfilled.

About the Author

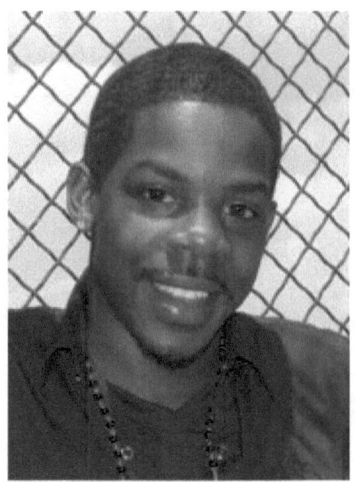

Arthur Ford is a writer and actor born and raised in the mean streets of Memphis, TN. He credits his Great-Grandmother for inspiring him to express himself through writing in a journal. This would lead to the publishing of his first book, *Expressions of a Young Prince*. Growing up in a social economic depressed area and later working for social services programs, he has gained a prospective from both sides of the tracks.

www.ingramcontent.com/pod-product-compliance
Lightning Source LLC
Chambersburg PA
CBHW021021180526